Boccioni
Unique Forms of Continuity in Space

ISBN O 946590 24 9
Published by order of the Trustees 1985
Copyright © 1985 The Tate Gallery All rights reserved
Designed and published by Tate Gallery Publications
Millbank, London SW1P 4RG
Printed by Balding + Mansell Limited, Wisbech

JOHN GOLDING

Boccioni Unique Forms of Continuity in Space

THE TATE GALLERY

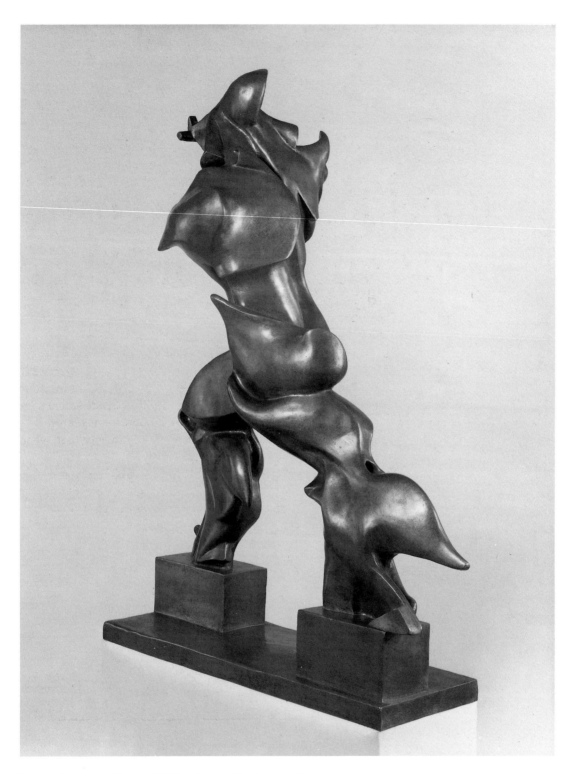

Umberto Boccioni (1882–1916) **Unique Forms of Continuity in Space**
(Forme uniche della continuità nello spazio) 1913
bronze, 114 × 84 × 37 cm, purchased by the Tate Gallery in 1972

Foreword

Umberto Boccioni's 'Unique Forms of Continuity in Space', one of the most exhilarating works of Futurist art, was acquired by the Tate Gallery in 1972. It was cast from the original plaster especially for the Gallery by a bronze foundry in São Paulo, Brazil. (The history of the various casts of this sculpture, none of which was made during Boccioni's lifetime, is given in Ronald Alley, *Catalogue of the Tate Gallery's Collection of Modern Art other than Works by British Artists*, London, 1981, pp.60–61, which also contains a full list of references). Visitors to the exhibition *Pioneers of Modern Sculpture* at the Hayward Gallery in the summer of 1973 may still remember the impact which this work made.

John Golding, one of our foremost historians of twentieth-century art, needs little introduction. His essay on Boccioni's 'Unique Forms' was given as the 54th Charlton Lecture at the University of Newcastle upon Tyne in February 1972. We are very grateful to him for agreeing to revise the essay for this series of booklets; and we are delighted to be able to reproduce three times the number of illustrations that accompanied its original publication. It was a happy coincidence that, when we first proposed the idea to Dr Golding, he was in the process of reviewing the splendid new *catalogue raisonné* of Boccioni's work for *The Times Literary Supplement*.[1] So it is very much in the light of his fresh thoughts about the artist that he has updated this stimulating and incisive account of a rare masterpiece of Futurism.

Richard Calvocoressi
Assistant Keeper, Modern Collection

[1] John Golding, 'In the interests of modernity' (review of Maurizio Calvesi and Ester Coen's *Boccioni: L'Opera Completa*), *T.L.S.*, 23 March 1984, pp.291–2.

Boccioni
Unique Forms of Continuity in Space

In 1907, at the age of twenty-five, Boccioni decided to settle in Milan. On the 2 January 1908 he began a new diary which he prefaced with a quotation taken from a fifteenth-century print: 'E bello doppo il morire vivere ancora'.[1] And in a sense Boccioni's career did begin in earnest with the move to Milan, then rapidly emerging as the most modern and fully industrialized city in Italy; certainly within the context of Italian life there could have been no more suitable base for a young artist who had just expressed his desire 'to paint the new, the fruit of our industrial age'.[2] The picture of Boccioni that emerges from the diary is that of a romantically self-conscious young man with a powerful, quick, somewhat raw mind. Already he was aware of the contradictory nature of many of his enthusiasms, even of certain contradictions within his own nature. On almost every page there is the sense of restlessness and driving ambition which was to characterize so much of what he subsequently wrote and produced, and which was to find its fullest expression some five years later in the work which he regarded as his sculptural masterpiece, his 'Unique Forms of Continuity in Space'.

The Milanese journal is an important document, for it demonstrates that while young Italian artists were in contact with many of the most stimulating intellectual currents that were informing late nineteenth- and early twentieth-century art, their visual fare (even at second-hand – in terms of photographs or reproductions) was decidedly less rich. In the diary Wagner looms large; we learn that Boccioni has been reading, amongst a host of others, Goethe, Baudelaire and Balzac. He comments on the ideas of Croce and d'Annunzio. Most prophetically for future developments he is exhilarated by his discovery of Schopenhauer and Nietzsche – the latter he refers to as his 'eroe sorridente'. Engels, another powerful influence, was soon to join the intellectual pantheon. On the visual side it is touching to learn that he has bought on the instalment plan volumes on Rembrandt, Michelangelo and Dürer; and it is in-teresting to note that he has spent two sleepless nights because of his discovery of reproductions of the work of Beardsley. But of the great Post-Impressionists whose influence was transforming the face of the visual arts north of the Italian border there is hardly a word. And the deep provincialism of Boccioni's vision at this time is underlined by the fact that when he visited Paris in 1907 he seems to have gone there primarily to look at an exhibition of Italian Divisionists – of their French

1 Gaetano Previati, **The Way of the Cross** (Via crucis) 1902, oil on canvas, *Civica Galleria d'Arte Moderna, Milan*

colleagues who had initiated the style he seems to have known or cared little.

At this time Boccioni still thought of himself exclusively as a painter and the most important early local influence on him was unquestionably Gaetano Previati, who in his current work was grafting a latter-day brand of Symbolism onto his own personal, somewhat morbid and at times almost expressionistic vision. Previati was an original and interesting artist, but perhaps not one who had all that much to offer a young man who was already dreaming of influencing the course of modern art. In the journal Boccioni quotes from Ibsen, whose writings must have helped to prepare him for the subsequent revelation of Munch, the most avant-garde of his visual sources to date; Boccioni probably knew of Munch's work only in reproduction although some examples of the graphic art had by now found their way to Milan. But 'Il lutto' (Mourning) of 1910, the most important of the Munchian pieces, is not a totally satisfactory painting; the handling of the subject is somewhat banal and the attempt to bend a Divisionist technique to expressionist ends is only partly successful. The work has about it, however, a certain wild intensity, and is interesting because the two protagonists in it appear several times in successive poses or stages of motion, a premonition of important developments soon to come.

In the meantime an event of enormous significance for Boccioni had taken place. The foundation Manifesto of Futurism had appeared on 20 February 1909[3]; it was published (significantly enough – for the movement was henceforth to keep its eye on Paris) first of all in French,

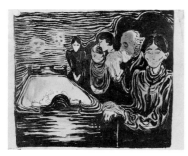

2 Edvard Munch, **Death Struggle** (Dødskamp) 1896, lithograph, *Munch-museet, Oslo*

3 **Mourning** (Il lutto) 1910 oil on canvas, *private collection*

although an Italian translation followed almost immediately. A few weeks later Boccioni met its author, Marinetti, and immediately formed a close friendship with him. Marinetti was an impresario of genius and he was to produce a platform for Boccioni that helped the artist to attract the fame and notoriety he was almost immediately to acquire. But Marinetti was also in some respects a dangerous mentor. If Boccioni's mind lacked subtlety, Marinetti's was crude; his sophistication was of the shallowest and it was liberally streaked with vulgarity. Like Boccioni Marinetti was vain and ambitious, although in a somewhat more casual, cavalier fashion; it is notable, for example, that while Marinetti always welcomed new recruits to the movement after it had been launched, Boccioni tended to take a jealous and exclusive stance – rivalry was not something he tolerated easily. Above all Marinetti was in a hurry and he fostered the inherent impatience and recklessness in Boccioni's make-up. But he was rich, he had been about a good deal, and to Boccioni he seems to have appeared as some sort of glamorous, latter-day cultural *condottiere*. Within the space of a few months Marinetti had swept him, with a welter of half-formulated ideas and catchy slogans, technically totally unprepared, into the twentieth century.

The aim of the manifesto was to shock, and herein at a very basic level lay its main originality. It ends, 'standing on the summit of the world, we launch our defiance once more at the stars'. What emerges most strongly is a campaign for the destruction of the past, including the artistic past (section ten reads: 'we want to demolish museums and libraries'), and an obsession with modern life and speed (section four says: 'we declare that the splendour of the world has been enriched by a new beauty, the beauty of speed'). Today, at the distance of more than seventy years, the manifesto still generates a sense of tremendous vitality and excitement; but when we come to ask ourselves, 'What is there in it that is truly new?', the answer is, 'Not much'. The ideas in it are implicit in the writings of Nietzsche and Bergson, and the Italian critic Papini was soon to point out that the basis for introducing urban and mechanistic iconography into the arts had been suggested by figures as diverse in background as Whitman, Verhaeren and d'Annunzio; while the iconography of a great deal of Futurist art had been very specifically anticipated in French poetry by Apollinaire, whom Marinetti knew and with whom he was exchanging ideas.

The first manifesto sets the tone of the subsequent welter of proclamations that were to bombard the French and Italian public, and although the techniques of shock and outrage were to become more sophisticated, and although the movement was to become more technologically orientated in its latter years, the *content* of the manifestoes was to remain, in the final analysis, eclectic. But seen against the provincialism of their own artistic and intellectual situation the fund of new ideas into which the Italians were delving seemed to them

miraculously new, and in saying what they said more loudly and more insistently than anyone hitherto, they succeeded in convincing a lot of other people of the novelty of their own premises; and it must be acknowledged that the sheer quality of exuberance and the noisiness of their onslaught did manage to give many ideas that had been formulated elsewhere a new and militantly twentieth-century emphasis.

The initial manifesto contains very little from a visual point of view, although section four contains what is perhaps the most famous passage in Futurist literature: 'a roaring motor car which seems to run on machine-gun fire is more beautiful than the Victory of Samothrace'. Also of importance for the visual arts is the implication that beauty exists only in struggle and can be the direct result of violence. But soon after their meeting Boccioni had introduced Marinetti to his painter friends Carrà and Russolo; together with two other painters whose names were later replaced by those of Severini and Balla, they drew up a manifesto of Futurist painting.[4] This came out on the 11 February 1910. It adds very little to the original foundation manifesto. Italy is again attacked as a 'gigantic Pompeii, white with sepulchres', art critics are condemned as dangerous and useless, and recognition is demanded for three older, neglected artists. Here Previati's name is joined by that of Segantini, another painter of ambitious Symbolist themes who worked in a roughly comparable Divisionist idiom. Medardo Rosso, the third of the artists to be mentioned was in many ways the most remarkable, and his sculptures of figures in motion, modelled with surfaces that suggest the dissolution of forms by light, were to have a considerable influence on Boccioni's art. In the manifesto a few suggestions are made concerning appropriate subject matter for Futurist painting; these include contemporary forms of travel and various aspects of night life in big cities.

However, with the Technical Manifesto of Futurist Painting, which appeared in April 1910, we are on more concrete and interesting ground. The tone is more practical and less inflated, and whereas the first painters' manifesto appears to have been drafted by Marinetti in conjunction with the artists, this technical manifesto is almost certainly essentially the work of Boccioni, who from now on dominates the visual ramifications of Futurism by virtue both of his intelligence and his superior talents, and also by his ambitions which had by now swollen into astonomic proportions.[5] The emphasis thoughout the manifesto is on movement, and the key passage occurs towards the beginning: 'the gesture which we would reproduce on canvas shall no longer be a fixed *moment* in universal dynamism. It shall simply be the dynamic sensation itself'. The ideas about this all-important dynamic sensation are not very specifically developed, and we must remember that as in the case of almost all the other manifestoes this technical manifesto was a blue-print for works of art that were *about* to be executed. But if we analyse the concept in the light of subsequent writings by Boccioni it

can be given a fairly precise meaning, and in the process Boccioni's debt
to one of the two or three greatest single influences on his thought and
art becomes transparently obvious. Bergson had undoubtedly been a
force in the formulation of the initial Futurist manifesto, although
Nietzsche is perhaps the thinker who stands behind the document most
squarely. What is progressive in the painters' technical manifesto, on
the other hand, owes most to Bergson, and a detailed analysis of
Boccioni's writings reveals very clearly that it was through a study of
Bergsonian doctrine that he was able to give tangible direction to what
was most positive and forward-looking in his own aesthetic programme.

Bergson first appeared in Italian translation in 1909, thanks to
Giovanni Papini who edited a volume called *La Filosofia dell'Intuizione*,
which incorporated the entire text of Bergson's *Introduction to Meta-
physics* (which had originally come out in France in 1903) as well as
extracts from his other work.[6] In the *Introduction to Metaphysics*,
Bergson writes: 'Consider the movement of an object in space. My
perception of the motion will vary with the point of view, moving or
stationary from which I observe it. My expression of it will vary with the
symbols by which I translate it. For this double reason I call such motion
relative: in the one case as in the other I am placed outside the object
itself. But when I speak of an absolute movement, I am attributing to the
moving object an inner life and, so to speak, states of mind. I also imply
that I am in sympathy with those states, and that I insert myself into
them by an effort of imagination'. Bergson goes on to say, 'Every feeling,
however simple it may be, contains virtually within it the whole past
and present of the being experiencing it, and, consequently can only be
separated and constituted into a 'state' by an effort of abstraction or
analysis'.[7] Bergson implies that the result of this sort of analysis can
only bring about partial understanding, and that although an artist in
his rendition of a subject can intuitively feel 'the throbbing of its soul'
his depiction of it will inevitably be 'an external and schematic repre-
sentation'. It will be the viewer's intuitive apprehension of the work that
will allow him to reassemble the schematic symbols meaningfully; '. . .
from intuition one can pass to analysis', Bergson says, 'but not from
analysis to intuition'. In Boccioni's writings of 1912 and 13 the
Bergsonian references become increasingly explicit; but it is in his
Fondamento Plastico della Scultura e Pittura Futuriste, published in March
1913, at a moment when he was either actually at work on the 'Unique
Forms of Continuity in Space', or just about to begin it, that for the first
time he quotes Bergson and makes explicit use of the distinction
between absolute and relative movement.[8] These Boccioni apparently
seeks to combine in a single image, and he thus implicitly challenges
Bergson by suggesting that the work of art can describe an analytic
depiction of the movement of a subject and can simultaneously
intuitively embody 'the throbbing of its soul'. In the same article he
writes: 'Have we found a formula that can render the [sensation of]

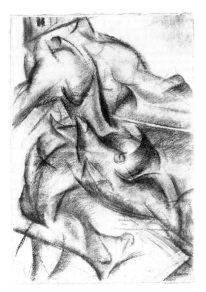

4 **Muscular Dynamism** (Dinamismo musculare) 1913, pastel and charcoal on paper, *The Museum of Modern Art, New York*

continuity in space? Formulas in art have given it its masterpieces and with them, periods of evolution have ended'.

After the verbal pyrotechnics of the early manifestoes, the major work of Boccioni's first Futurist phase, 'La Città che Sale', comes as something of an anticlimax, although it is a solid, ambitious work that marks a definite step forward for him. But while the technique and the iconography are revealing of the limitations and inconsistencies of early Futurism, certain aspects of the work project us forwards and towards a greater understanding of the 'Unique Forms'. We learn from a letter of Boccioni's, written in November 1910, that the work is nearing completion and he refers to it as 'a great synthesis of labour, light and movement'.[9] The work is superficially Futurist in that the theme is that of a rising city, and the painting is undoubtedly imbued with a sensation of dynamic intensity which was the state towards which Futurist art was aspiring. The technique, on the other hand, is basically a compromise between Impressionism and a form of Divisionism still very close to that practiced by Previati, and at first sight the imagery is disappointingly old-fashioned in view of the fact that Boccioni's avowed intention here was 'to erect to modern life a new altar vibrant with dynamism'.[10] Having vaunted the superior beauty of the motor car over the Victory of Samothrace, it is somewhat baffling to find the horse glorified as a symbol of power and labour, and by the exaggeration of the blue forms of the halters to find it furthermore transformed unmistakably into a Pegasus-like creature evoking references to a despised classical past. There are Symbolist prototypes for this aspect of the painting's imagery (one thinks particularly of the work of Redon) and Boccioni does in fact refer to the work as being Symbolist; and here we are faced with one of the contradictions inherent in the movement and responsible for its eventual visual defeat. For while the Futurists flaunted the concept of modernity like a banner, their attitude towards the nineteenth century was equivocal; they could never make up their minds what they wanted to take from it and what to reject. Their visual starting point was in Symbolism and Impressionism, while Cubism, which they were soon to use to 'modernise' the appearance of their works, had evolved precisely as a reaction to these styles which were so essential to the scaffolding from which the Futurists originally launched themselves into the twentieth century.

The machine-animal analogy is a recurrent theme in Futurist art, but whereas their contemporaries in France and Germany tended to use mechanistic imagery as an instrument of satire and irony and to turn human beings into machines (in the visual field the work of Duchamp, Picabia and Klee comes immediately to mind), the Italians, probably for the simple reason that they were experiencing their own industrial revolution so remarkably late in the day, glorified and indeed deified the machine, and, in the process, inevitably endowed it with human or animal connotations. Marinetti's ode to his automobile *A l'automobile*,

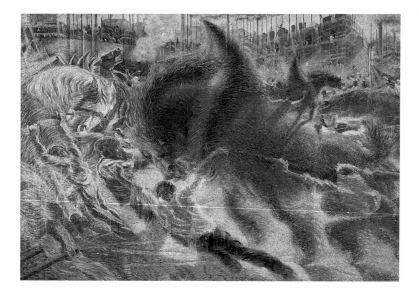

5 The City Rises
(La città sale) 1910–11
oil on canvas, *The Museum of Modern Art,
New York, Mrs Simon Gugenheim Fund*

published in 1905, came out again three years later under the title '*A
Mon Pégase*'[11], and in it the horse is identified both with the motor car
and airplane; similar metaphors are employed by Buzzi, Auro d'Alba
and other Futurist poets. Boccioni's interest in the horse (which was to
be the instrument of his own premature death in 1916),[12] mounts
during the Futurist years to obsessional proportions. Here the giant
beast, instrument of industry and symbol of the machine, seems to pull
his pigmy masters into the city's rhythms; and in the case of the figure at
the bottom right, the limbs of man and beast appear to interpenetrate
and fuse. The sketches for the painting make it clear that the man's
legs in fact disappear off the edge of the canvas, but the composite
image, even if it was achieved unconsciously, heralds very directly the
powerful, superhuman forms of the great striding figure of 1913 – the
muscular configurations evoke comparison in particular with a sketch
directly linked to the sculpture and called 'Dinamismo Muscolare'. That
Boccioni was at least subconsciously aware of the references to flight in
the painting is to a certain extent confirmed by the fact that after its
completion he wrote, 'One must forgive some mistakes to the man who
attempts to fly'.[13] The great sculpture, too, one feels, aspires to an
airborne state.

'The City Rises' was shown at the Esposizione Libera which opened
in Milan in May 1911, and it brought Boccioni indirectly into contact
with yet another important influence on the evolution of his art. The
exhibition was savagely attacked by the Florentine critic Ardengo
Soffici, with whom Boccioni may actually have come to blows in one of
the great battles of Futurist mythology,[14] although immediately after
the encounter Soffici was to become a loyal friend and champion. The
previous year Soffici had published a perceptive essay on Bergson called

Le Due Perspettive,[15] and it seems likely that it was through Soffici, an infinitely more philosophical and reflective character than Marinetti, that Boccioni came to a closer understanding of Bergson's thought; and it was almost undoubtedly Soffici who introduced Boccioni to photographs of Cubist painting and who thus prepared the way, visually and psychologically, for his all-important visit to Paris later in the year.[16]

It was probably at the time of the Esposizione Libera that Boccioni began work on the studies for the triptych that represents perhaps his major achievement as a painter, and which was to dominate the vast Futurist exhibition mounted in Paris at Bernheim Jeune's in February 1912. The title for the triptych, the 'States of Mind', was derived from Bergson's terminology, and certainly to Boccioni it seemed as if the concept embodied in these three words held the key to a whole new range of exciting subject matter. The triptych, set in the dynamic environment of a modern railway station, consisted of a central panel, the 'Farewell', flanked on one side by 'Those who Go' and on the other by 'Those who Stay'. The iconography is not without importance for the 'Unique Forms' which synthesizes, in a sense, the different kinds of movement explored in the paintings, and which incorporates into itself some of the mechanistic forms of the locomotive which dominates the centre of the middle panel like some malevolent divinity.

Boccioni arrived in Paris around the middle of October of 1911 and the final versions of the 'States of Mind' were either reworked, or, in all probability, completely painted after his return to Milan the following month. And they demonstrate very clearly his extraordinarily lucid and intelligent (if basically superficial) adaptation of Cubist techniques to

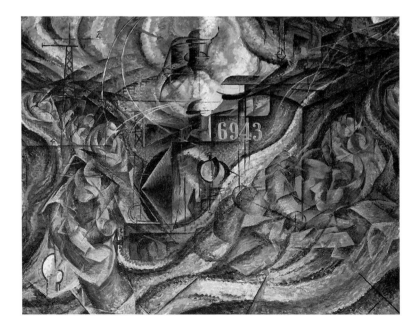

6 **The Farewells – States of Mind II**
(Gli addii – Stati d'animo II) 1911
oil on canvas, *The Museum of Modern Art,*
New York, gift of A. Nelson Rockefeller

purely Futurist ends. In the preface to the exhibition, Boccioni writes for the first time of Futurist 'lines of force', and here the swirling, emotive Munchian rhythms of the billowing steam, which had covered the entire surface of sketches executed a few months earlier, are played off against the vertical, horizontal and diagonal force lines derived from the linear grids of classical Cubism; the straight lines give the painting a new sense of structure and enable Boccioni to compartmentalise the surface into various spatial areas or cells into which he fits the protagonists of his drama, the embracing couples and the instrument of their separation. In the preface Boccioni talks also for the first time of 'battles of planes' in terms which show an appreciation of the sort of Cubism evolved by Picasso and Braque in late 1909 and 1910, where the whole pictorial surface is resolved in terms of hinged, interacting and semi-transparent planes.[17] Finally, the stencilled letters, introduced into Cubist painting only a few months earlier, defiantly proclaim the picture's true modernity.

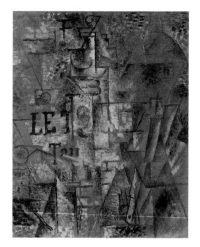

7 Pablo Picasso, **Still-Life 'Le Torero'**
1911, oil on canvas, *private collection*

In 'Those Who Stay', the Cubists' analysis of solid form and its surrounding space has been given a new direction or emphasis by the way in which the shapes into which the figures are abstracted are now for the first time unfurled into the atmosphere around them, like wood-shavings still adhering to their parent bodies, a device with exciting sculptural possibilities that Boccioni was soon to explore. In 'Those Who Go' we encounter another important source for Boccioni's sculpture, because the treatment of the heads appears to combine the Cubists' use of multiple viewpoints with the effects of chronophotography, or of the experiments with time exposure of his photographer friend Bragaglia,

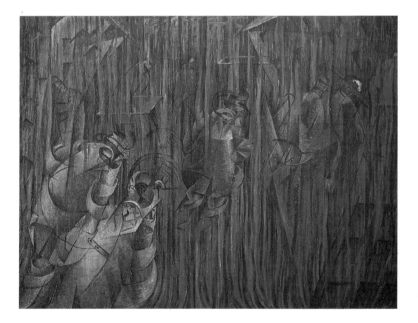

8 **Those Who Stay – States of Mind II**
(Quelli che restano – Stati d'animo II)
1911, oil on canvas, *The Museum of Modern Art, New York, gift of A. Nelson Rockefeller*

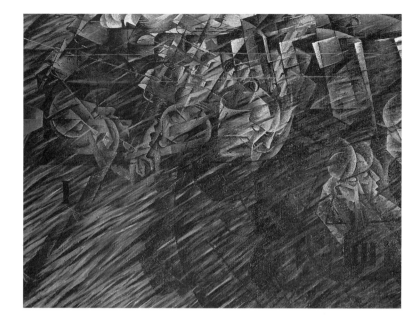

an influence which Boccioni was to deny very violently, partly one suspects, because, by Bergson's definition, cinematic motion was 'analytic' and therefore our apprehension of the subject's true essence can only be partial and additive.

The 'States of Mind' are a remarkable achievement, coming as they do from a young man who was digesting five years' worth of revolutionary painting in the course of a few brief weeks. But once again their brilliant modernity is based on a strongly retrogressive support. For their iconography is almost certainly derived from a work that must have seemed even by Boccioni's still fundamentally provincial standards, somewhat 'passatista'. In 1898 the Breton painter Charles Cottet had shown at the Venice Biennale a triptych called 'Les Pays De La Mer' (with, on the right, 'Ceux Qui Restent', in the centre 'Les Adieux', and on the left, 'Ceux Qui Partent'); this had been installed in the following year in the Museo Bottancini (now the Museo Civico) of Padua, where Boccioni had spent some of his student years. And whereas the confrontation serves only to accentuate the dynamic intensity of Boccioni's reworking of the same theme, it demonstrates more forcefully than words could ever express the precariousness of the visual basis on which his modern vision of the universe was being built.[18]

Boccioni's Technical Manifesto of Futurist Sculpture is dated April 1912, although it did not appear publicly until October.[19] However, in a letter of 15 March, he says 'I am obsessed these days by sculpture. I think I can perceive a complete revival of this mummified art'.[20] The exhibition of Futurist painting had been a tremendous 'succès de scandale' but it had received an almost uniformly hostile reception from

the French press (few of the exhibits had been of the calibre of the 'States of Mind') and several critics had remarked, with a certain amount of justification, on the inadequacy of many of the works. There is little doubt that Boccioni, summing up the scene around him with an eye that was quick and competitive, saw that there was as yet no such thing as a school of Cubist sculpture, and he sensed, very shrewdly, how he could best and most quickly make his mark. The sculpture manifesto has all the urgency of the earlier broadsheets but it is a more disciplined and incisive document; and whereas the earlier manifestoes were to be of the utmost importance in the most general way, in that they provided artists all over the world with an instant do-it-yourself aesthetic kit, the sculpture manifesto proved ultimately to be technically and practically of greater value to subsequent artists than to Boccioni himself.

The first exhibition of his sculpture took place in Paris in June 1913. Eleven pieces were shown and in his autobiography Severini tells us that all these were executed within a space of sixteen months, so that once again theory appears on the whole to have preceded practice.[21] Of the works exhibited only three have survived. None of Boccioni's sculptures appear to have been cast in bronze during his life-time and most of them perished after an exhibition in Milan early in 1917, when they were hacked to pieces by workmen anxious to clear the space in which they were being stored. Marinetti and a friend collected together the fragments to which The 'Unique Forms of Continuity in Space' and 'Development of a Bottle in Space' had been reduced, and the works were restored; the fact that these two pieces were selected for salvage might indicate that they were recognised as being the best. Fortunately photographs of the destroyed works survive; and it is one of the paradoxes and ironies of Futurism that while the artists inveighed against museums, critics and history, they loved to be catalogued and chronicled. The exact order in which the sculptures were executed will probably never be definitely established (the order in which they are listed in the Paris catalogue appears to be totally arbitrary).

The first original and important point Boccioni makes in the manifesto is that the new sculpture is to be a sculpture of environment. That is to say, sculpture is no longer to stand out as a mass or silhouette against the space and atmosphere around it, rather it will carry its own environment within it: 'No one can any longer believe that an object ends where another begins and that our body is surrounded by anything – bottle, automobile, house, tree, road – that does not cut through it and section it in an arabesque of directional curves' . . . 'We therefore cast all aside and proclaim the absolute and complete abolition of definite lines and closed sculpture. We break open the figure and enclose it in environment'. Boccioni acknowledges the art of three modern French sculptors, Rodin, Bourdelle and Meunier, although he feels their limitations offset their positive achievements. He dwells at greater length on Rosso, whose originality he rightly exalts. He feels however

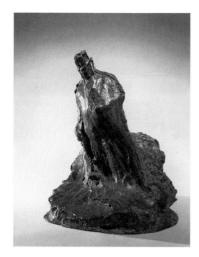

10 Medardo Rosso, **The Bookmaker**
(L'uomo alle corse) 1894, bronze,
Hirshhorn Musuem and Sculpture Garden,
Smithsonian Institution, Washington

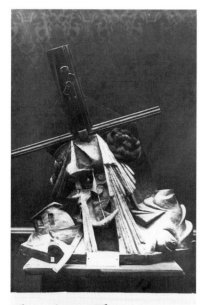

Boccioni — Fusione di una
testa con una finestra —
1913
Insieme pastico gesso legno vetro crina

11 **Fusion of a Head and a Window**
(Fusione di una testa e di una finestra)
1912–13, plaster, destroyed

that Rosso's work suffers from its two-dimensionality, its ephemeral quality and its lack of structure and 'universality', defects which are the result of the lightness and rapidity of execution. Having announced the abolition of definite lines Boccioni now goes on to say that Futurist sculpture will be characterised by its use of the straight line, whose 'bare, fundamental severity will symbolise the severity of steel that determines the lines of modern machinery'. The statement clearly springs from his appreciation of the cardinal part played by straight lines in contemporary Cubist painting, but the contradictions within his own art were mounting.

These contradictions are painfully obvious in 'Fusion of a Head and a Window', almost certainly the first sculpture for which a visual record survives. On stylistic grounds I think that we are forced to place it after Boccioni's contact with Picasso's first fully Cubist series, the paintings executed at Horta del Ebro during the summer of 1909, and which Boccioni would have seen at Kahnweiler's gallery which he visited on his 1911 trip to Paris. Boccioni himself dated the work 1911[22] and it is just conceivable that he might have produced it right at the end of the year, on his return to Milan; however, we know he was painting feverishly at this time for the Paris show and it seems more likely that it comes immediately after the date given for the sculpture manifesto. And it is in a sense ironic that the least accomplished of Boccioni's sculptures should be the one that best fulfills what is perhaps the most immediately prophetic aspect of the theoretical programme. Section four of the conclusion reads: 'Destroy the wholly literary and traditional nobility of marble and of bronze. Deny the exclusiveness of one material for the entire construction of a sculptural ensemble. Affirm that even twenty materials can compete in a single work to effect plastic emotion. Let us enumerate some: glass, wood, cardboard, iron, cement, horsehair, leather, cloth, mirrors, electric lights, etc., etc.' (there appear to be five different materials used in 'Fusion of a Head and a Window').

The confrontation with Picasso's 'Femme aux Poires' is revealing in that the painting is so much more strongly volumetric – one might even say so much more sculptural in feeling – than Boccioni's three-dimensional variant, which is any case basically a heavy bas-relief. Picasso did produce a sculptural counterpart to the Horta heads when he returned to Paris in the autumn of 1909; but the fact that the celebrated bronze 'Head' remains an isolated phenomenon in the first major, analytic phase of Cubist art serves to underline the point that with the dismissal of traditional, single viewpoint perspective the Cubists had introduced what might be called a three-dimensional or sculptural completeness into their paintings, which within the context of a Cubist aesthetic made sculpture seem temporarily redundant.

Picasso's 'Head' appears to have been known to Boccioni, at least in reproduction, and the final metamorphosis of the 'Fusion of a Head and a Window', the 'Antigrazioso', probably of the winter of 1912–13 gives

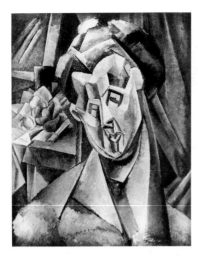
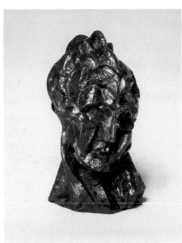

12 Pablo Picasso, **Femme aux Poires**
1909, oil on canvas, *The Florence May
Schoenborn and Samuel A. Marx Collection,
New York*

13 Pablo Picasso, **Head of a Woman**
1909 (cast 1960), bronze, *Hirshhorn
Museum and Sculpture Garden,
Smithsonian Institution, Washington*

the impression of being simply a more agitated, baroque reworking
of the Cubist original. The second, intermediate work in this series,
'Testa + Casa + Luce', appears to have been the most exciting of the
three, although once again it is basically a very exaggerated form of
bas-relief. And despite the sculpture's undeniable power, a related,
earlier painting, 'Costruzione Orizzontali', conveys the sensation of the
dynamic dissolution of space in a more effective and convincing fashion.
This is partly due to the effects of tranparency which obviously at this
moment in time came more easily to painting than to sculpture, and
also to the use of colour, which in the painted head strongly suggests the
decomposition of matter by light; the spiralling rhythms which echo
each other like ripples in a well also give the painting a life and vibrancy
which one feels the sculpture must have lacked. Boccioni was clearly
aware of the problems posed by the confrontation between the two
mediums, and two slightly later works show him coming to grips with
them, with his now familiar approach which involved a blend of daring
and compromise.

The first and most obvious problem was how to introduce a greater
sense of movement into his sculptures. His attempts to bring the
surrounding, physical *ambiance* of a figure into it and through it had
been only partially successful, and had posed great technical problems –
the progressive abandonment of diverse materials and the virtual
elimination of architectural surround in his *Antigrazioso* bear witness to
this. The next obvious step was to put his figures into motion in such a
way that they would seem to advance and partake of the space and
atmosphere around them. The Futurists had from the start inveighed

15 **Ungraceful** (Antigrazioso) 1912–13
plaster, *Galleria Nazionale d'Arte Moderna,*
Rome

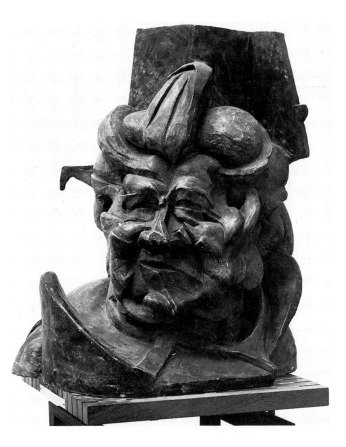

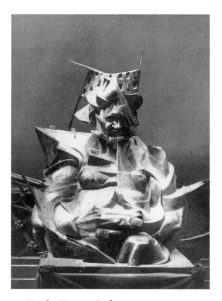

14 **Head + House + Light**
(Testa + casa + luce) 1912
plaster, destroyed

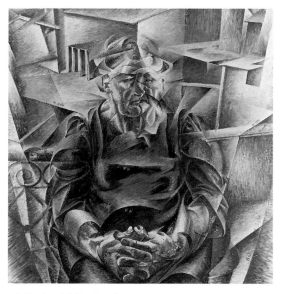

16 **Horizontal Construction**
(Costruzione orizzontale) 1912
oil on canvas, *Bayerische*
Staatsgemäldesammlungen, Munich

against photography, and in his work hitherto Boccioni had for the most part avoided any suggestion of the cinematic rendition of movement. But in order to retain the all-important temporal element which came with the rejection of single, fixed viewpoint perspective, he was now forced to seek help from this much despised medium. The only surviving photograph of his 'Synthesis of Human Dynamism', surely the first of his great striding figures and a work probably of late 1912–1913, which shows it squarely in a side view,[23] and so to speak in full extension, reveals very clearly a repetition and modification of the linear rhythms that define the trajectory of the legs (and to a lesser extent the arms), that can only have come through a study of chronophotography or contemporary paintings that derived directly from it. That chronophotography played an important part in the final 'Unique Forms' is to a certain extent confirmed by the fact that in a letter of 1913 written to the organiser of a proposed group exhibition Boccioni offers to bring the 'Unique Forms' back from Paris, where it had remained after the summer exhibition, but he goes on to request, and indeed demand, that Bragaglia's photographs of figures in motion be excluded from the show.[24] His always fierce desire to burn the evidence was steadily mounting.

'Synthesis of Human Dynamism' must have been a very compelling work, but to judge from photographs, it can't have been completely satisfactory or convincing, mainly because the upper parts of the figure (the torso, head and arms) are exaggeratedly heavy and leaden so that they seem to make the movement of the lower limbs painful and almost ineffectual; the work seems to illustrate very graphically the sentence in the manifesto which begins: 'We proclaim that the whole visible world

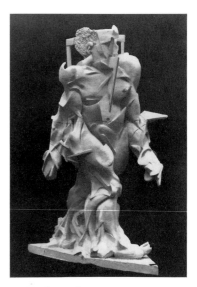

17 **Synthesis of Human Dynamism** (Sintesi del dinamismo umano) 1913 plaster, destroyed

18 Anton Giulio Bragaglia, **Greeting** (Salutando) 1911, chronophotograph, *Centro Studi Bragaglia, Rome*

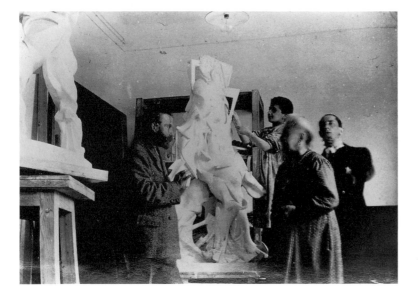

19 Boccioni's studio: (from right to left) Boccioni, his mother, an assistant and Giacomo Balla. The sculpture in the middle is **Synthesis of Human Dynamism** 1913, while to the left, part of **Spiral Expansion of Muscles in Movement** 1913, can be seen

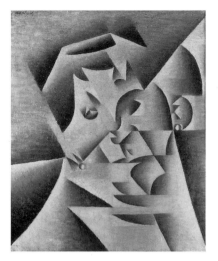 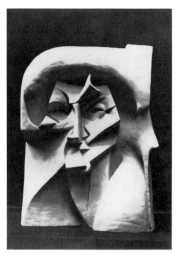

20 Juan Gris, **Portrait of the Artist's Mother** 1912, oil on canvas, *from the collection of the late Douglas Cooper*

21 **Abstract Voids and Planes of a Head** (Vuoti e pieni astratti di una testa) 1912, plaster, destroyed

must fall in upon us . . .'. The armature which bisects the trunk and head was probably partly inspired by structural necessity, but it reads also as a vestige of the architectural forms Boccioni had incorporated into his earlier works, and in its abstraction it prefigures the dramatic, machine-like forms to which the head of the final striding figure is reduced.

Another problem that had faced Boccioni was how to achieve a more active and dynamic treatment of volume itself. Here he appears to have turned for advice to the Cubist portraits executed by Juan Gris in 1911–12, which use a diagonal grid system and sharp juxtapositions of light and dark to analyse form and animate the picture surface. The title of 'Vuoti e Pieni Astratti di una Testa', a work probably of late 1912, in itself suggests a move to a less literal depiction of the subject and an interplay between concave and convex forms, or between voids and solids. This results in strong, dramatic contrasts of light and shadow, and these in turn suggest a dissolution of form and even a sense of weightlessness and transparency within a strongly sculptural context.

In the first technical manifesto of Futurist painting the artists had proclaimed that they attached equal importance to the psychological life they ascribed to objects and machines as to that of animals and human beings, and Boccioni spelt out his sculptural explorations of the human form by a simultaneous investigation into the 'Development of a Bottle in Space'. The original sketch, which combines complexity and lucidity in equal degrees, may once again owe something to Juan Gris, the most expository of the great Cubists. Boccioni's drawing illustrates yet another phrase of the sculpture manifesto which suggests a sound basis for a new, more open treatment of sculptural form. 'We have to

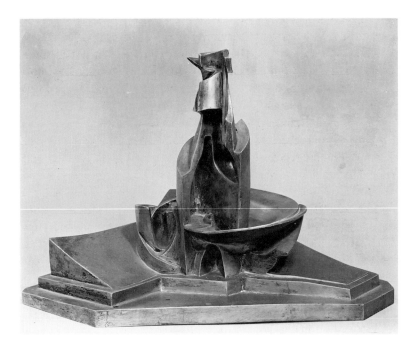

22 **Development of a Bottle in Space**
(Sviluppo di una bottiglia nello spazio)
1912 (cast 1931), silvered bronze,
*The Museum of Modern Art, New York,
Artistide Maillol Fund*

start from the central nucleus of the object that we want to create', Boccioni had declared, 'in order to discover the new laws that link it . . . invisibly but mathematically to the APPARENT PLASTIC INFINITE and the INTERNAL PLASTIC INFINITE'. Working with a humble, matter of fact subject, Boccioni seems to have experienced a sense of liberation and his 'Bottle' is, except for the 'Unique Forms', his most perfectly realised sculpture, and a minor masterpiece. The inner cylinder of the bottle has been laid bare and seems to unfold and spiral quite naturally and inevitably into the space around it, while the tilted architecture of the table top and the basin-like form of the bottle's first lateral expansion act as a support for the rest of the object's vertical ascent. More than in any other of Boccioni's works in three dimensions the dynamic, spiralling forms which came most naturally to his hand are played off against the straight lines which he had originally felt would constitute the modernity of his sculpture, to achieve a perfect harmony. In a second, lost version of the subject, the straight line is sacrificed to violent, unbalanced corkscrew effects which result in a feeling of instability and disintegration.

The same general process is observed in the next two striding figures that lead directly into the final masterpiece, now almost surely (like the second bottle) works of the winter and early spring of 1913. 'Muscoli in Velocità' is almost certainly the first. It is mounted on a rectangular base and the figure is given further architectural support by the way in which the successive forms that constitute the lower limbs appear almost as a continuous flux of shapes; the left arm of the figure appears

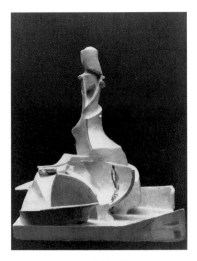

23 **Forms-forces of a Bottle**
(Forme-forze di una bottiglia) 1913
plaster, destroyed

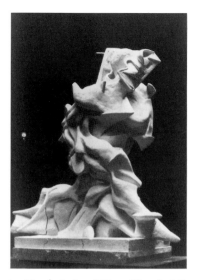

24 **Muscles in Speed** (Muscoli in velocità) 1913, plaster, destroyed

to have been truncated, while the right arm seems to be joined to the foremost leg, so that the composition is more stable and better balanced than that of its predecessor. However, the urgent forward motion of the torso over the solid tangle of legs still produces a sensation of almost intolerable strain, and we feel that the figure is being brought to its knees as it surges forward.

The companion piece, 'Spiral Expansion of Muscles in Movement' has an oval base and reverts to the earlier treatment of the legs as separate elements, and the repetition of linear rhythms is less aggressive so that the debt to photography is more disguised. The forms of legs and buttocks are slightly lumpy and clumsy but they support the upper part of the body very convincingly because the torso is now virtually armless and erect, while the head has been reduced in scale and relieved of its architectural encumbrances. However, to counteract the strong forward drive, Boccioni has been forced to exaggerate the bulk of the advancing leg, so that once again the sense of ongoing urgency is painfully checked and as disturbing as the spectacle of a long distance runner performing heroically in a plaster cast.

The solution in the final work of the series, the 'Unique Forms of Continuity in Space' is blindingly simple and totally successful. The legs are anchored to relatively small but heavy blocks of slightly unequal size: and while these act as a strong architectural support, at the same time by their placing they force on us an awareness of the full span of the figure's giant stride. The forms of the body are taut, and eminently sculptural, but, as in the 'Bottle', negative space is almost as important as solid mass, so that there is also an air of weightlessness, and the sense

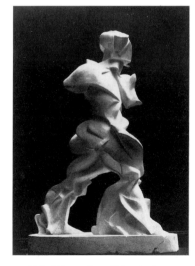

25 **Spiral Expansion of Muscles in Movement** (Espansione spiralica di muscoli in movimento) 1913 plaster, destroyed

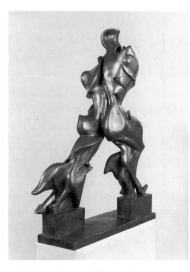

26 **Unique Forms of Continuity in Space** 1913

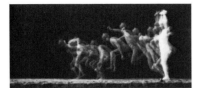

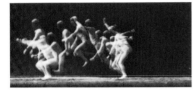

27 Etienne-Jules Marey, chronophoto-
graph of figure during standing jump,
c.1882, *Collège de France, Paris*

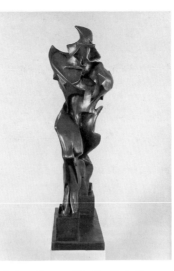

28 **Unique Forms of Continuity in Space**
(frontal view) 1913

of speed is now euphoric and heady. The tough, elastic limbs convey
overwhelmingly the sense of a new *kind* of motion, the motion pro-
claimed by the celebrated photographer Marey in his famous essay on
La Machine Animale.[25] We sense that this is a creature driven by forces
that are only partly human, capable if necessary of flight and of
competition with the deified racing automobile at top velocity. The
bulging muscles, half metal, half flame are pulled back to reveal the
trajectory of earlier phases of motion, but these only serve to empha-
sise the inevitability of the forward drive. In her book on Futurism,
Marianne Martin quite rightly compares this image with Marinetti's
vision of the mechanical superman, whose advent he proclaimed in
1915 in his interventionist tract *Guerra Sola Igiene del Mondo*. This
being, Marinetti claims, will be 'built to withstand omnipresent speed.
He will be endowed with unexpected organs adapted to the exigences of
continuous shocks . . . (there will be) a prow-like development of the
projection of the breastbone which will increase in size as the future
man becomes a better flyer'.[26] He also appears to carry within himself
the instrument of his own destruction, for he wears his faceless mask
like the handle of a great metal sword which his forward movement can
only drive ever deeper.

There are of course endless prototypes for the image of a single,
advancing figure, and Albert Elsen has pointed out that in February
1912 a bronze of Rodin's 'Walking Man' was set up outside the French
embassy in Rome to the accompaniment of great publicity.[27] We know
from Severini that soon after the Paris exhibition, towards the end of
April 1912, he introduced Boccioni to Duchamp-Villon, Archipenko,
Brancusi and to a shadowy figure called Agero, whose work appears
to have sunk without trace, although Apollinaire in his review of

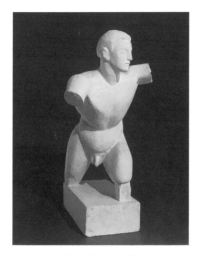

29 Raymond Duchamp-Villon, **Torso of a young Man** 1910, plaster, *Hirshhorn Museum and Sculpture Garden, Smithsonian Institution, Washington*

Boccioni's sculpture show implies that he may have been an influence.[28] It is just possible that Boccioni might have seen his own work as updating Duchamp-Villon's 'Torso of a Young Man' of 1910. Certainly Archipenko's work of 1912 and 1913 makes daring use of the interplay of solid and void, and Archipenko and Brancusi may well have encouraged Boccioni towards a more abstract, more daring treatment of sculptural forms, although Brancusi's art, one feels, would have withheld itself safely from the onslaught of Boccioni's restless, aggressive mind.

But it is perhaps fairest to see Boccioni's evolution, at least in the final 1913 phase, in terms of a more purely internal development which involved a recognition, however grudging, of an indigenous Italian and ultimately classicising tradition, which he had originally rejected out of hand. The most marked stylistic change in his own work had been from a sculpture which attempted to use only the straight line, through to a work which exults in the spiral. One of the two or three dozen sketches of striding figures which were shown at his first exhibition of sculpture shows the by now familiar configuration of limbs given female attributes and transformed unmistakably into a Daphne figure, and this would imply, if not necessarily familiarity with Bernini's early masterpiece, (although it is a work that Boccioni must almost certainly have known and which is an ode to the sort of 'spiral architecture' to which Boccioni eventually saw his sculpture as aspiring), at least a concession to the universality and continuity of the forms and themes of the past.

From the start what had distinguished Boccioni's sculpture sharply from that of his most progressive contemporaries in France was his scornful dismissal of the possibilities held out by various forms of

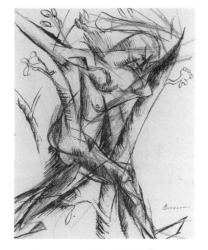

30 **Dynamism of a Human Body** (Dinamismo di un corpo umano) 1913 pencil and ink on paper, *private collection, Milan*

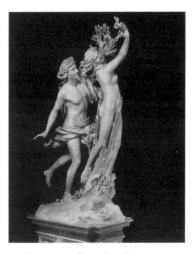

31 Bernini, **Apollo and Daphne** 1622–24, marble, *Galleria Borghese, Rome*

primitive art. This is already implicit in his sculpture manifesto, and it becomes a bitter indictment of other modern sculpture in the statement published by *Lacerba* in March 1913. In April came his hysterical declaration that Futurism was being plagiarised in France,[29] and with the desire to vaunt Italy's primacy, seems to have come to an unwilling recognition of the splendours of her cultural heritage. The final armless image with its muscular contortions reminiscent of fluttering wet drapery owes more than a little to the originally despised forms of antiquity. The Victory of Samothrace and the speeding automobile have in a sense become one.

In his sculpture manifesto, Boccioni had announced the death of the conventional public monument and had attacked traditional museum presentation, but we know from contemporary photographs that his work was designed to be seen raised quite high on plinths; and there is something both awe-inspiring and a little frightening about the vision of this Futurist demi-god striding sightlessly through space above the heads of a public that Boccioni, in his letters, talks of with hatred and contempt – 'scum', he says at one point 'whom we must lead into slavery'.[30] The influence of visual Futurism was almost wholly positive and liberating, but to emphasise only the forward-looking elements of the movement, as all art-historians have done, is to falsify the total picture. One of the great tragedies of the twentieth century has been the association of certain kinds of radicalism with the extremes of reaction and authoritarianism; although Futurism was only one of the paths that led to Fascism, on the political front it was a path that was straight and short. And from Boccioni's political allegiances and proclamations one is perhaps justified in suggesting that his tragic death did at least

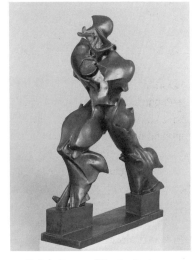

32 **Unique Forms of Continuity in Space** 1913

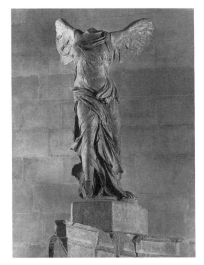

33 **The Victory of Samothrace**
Musée du Louvre, Paris

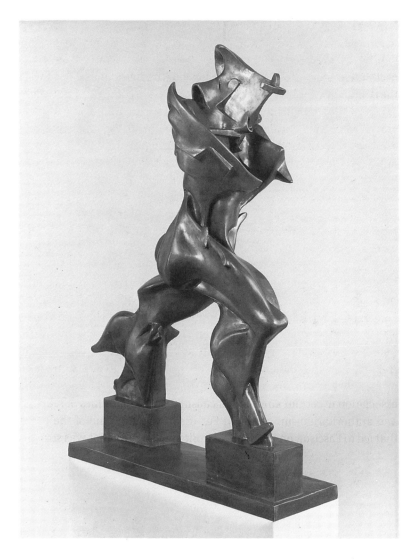

spare posterity the spectacle of a once deeply revolutionary artist seated next to his friend Marinetti in the Fascist academy. His use, even if it were partially unconscious, of some of the conventions and forms of a classical past was to give the sculpture much of its power and beauty, and his adaptation of them has been to progressive, original ends. But for the first time in twentieth-century art, the sources of official Fascist imagery are hinted at, and the 'Unique Forms of Continuity in Space' is a revolutionary work which carries within it the seeds of reaction.

With its completion, Boccioni seems to have realised that he had achieved the definitive masterpiece for which he longed. We know of only one sculpture of 1914, completely different in style and feeling, and his subsequent work shows him slowly turning his back on what had been most forward-looking in his vision. The paintings of 1913 and 1914 which were to evolve into his characteristic late manner show

him feeling his way back through Cubism to Picasso's Negroid style and eventually to what can only be described as a brilliantly accomplished but fundamentally academic form of Cézanneism. The encounter with Cubism at the end of 1911 had overnight 'modernised' his art, but within the space of three brief years, his art had executed, often with dazzling bravado, a total short circuit.

Boccioni devoted the months following the completion of the 'Unique Forms of Continuity in Space' to finishing his book *Pittura Scultura Futuriste*, which came out early in 1914. It contains little that was not present in the earlier visual manifestoes, and it lacks the sense of excitement and discovery that still make these such compulsive reading; but it remains the fullest and most lucid contemporary guide to Futurist visual aesthetics. In the light of his own subsequent development as a painter, his insistence on Futurism's place at the forefront of the avant-garde seems strangely irrelevant, and as the final credo of one of the most gifted and influential artists of his age, it is sadly lacking in generosity; and indeed the book is interesting not least of all as a classical study in artistic paranoia. French art from Delacroix onwards, Boccioni claims, has been preparing the way for the new Futurist sensibility. Cézanne, we learn, is a fine painter because he is in the Italian tradition. Cubism is cold, formalistic and ultimately a return to the academy. Orphism is livelier but it goes little beyond Impressionism and owes much to Futurism. The Germans fare slightly better but they lean too heavily on France. The palm is awarded by implication to the Russians, partly, one can't help suspecting, because Boccioni had seen very little of their work and felt it wasn't much competition.[31]

In fact, however, Boccioni's evaluation was in a sense prophetic, for particularly in the domain of sculpture it was the Russians who were to a large extent to realise Boccioni's programme. In the years immediately following 1917, theirs was to be the most genuinely experimental art in the world, and they put their faith wholeheartedly in a technological revolution which the Futurists had proclaimed, but from which Boccioni at least had almost immediately withdrawn. They experimented with the materials he had advocated, and on occasion they produced art that was environmental in a wider sense than he imagined. The Futurists had seen art as a liberated way of life – the Russians, for a brief while, lived it. In the final analysis, Futurism was more important for a particular mood, an expectant climate which it helped to create within the arts rather than for any of the more tangible products it left behind. In a sense the movement in its entirety was its own major monument, and proof of its enduring vitality is the fact that successive generations of artists have raised it higher on new bases of their own. But as the pyramid ascends, it must always carry the 'Unique Forms of Continuity in Space' at its apex.

Footnotes

1 The Milanese diary is reproduced in its entirety in *Boccioni*, Guido Ballo, Milan, Il Saggiatore, 1964, pp.403–424.

2 From an entry in Boccioni's earlier diary, dated 14 March 1907. Reprinted in *Archivi del Futurismo* (Raccolti e Ordinati de Maria Drudi Gambillo e Teresa Fiori), Vol. I, Rome, De Luca, 1958, p.225.

3 The Manifesto has been reproduced innumerable times. The translations are the author's.

4 The painters whose names were later withdrawn were Bonzagni and Romani.

5 Boccioni wrote the preface to the exhibition held at Bernheim-Jeune in Paris, 5–12 February 1912, although all five painters showing signed it. On the basis of style and content, it seems more than likely that he drafted the technical manifesto of painting also (see also Ballo, op.cit., p.317).

6 *La Filosofia dell' Intuizione; Introduzione alla Metafisica ed astratti di altre opere*, a cura di Giovanni Papini, Lanciano, Editore Carabba, 1909.

7 Henri Bergson, *An Introduction to Metaphysics*, translated by T.E. Hulme, London, Macmillan, 1913, pp.1–2.

8 The article was published in *Lacerba*, 15 March 1913. Correspondence published in the *Archivi* concerning the publication of various *Lacerba* pieces suggests that for the most part, articles came out within a few days or weeks of being written. The passage from Bergson quoted by Boccioni reads, 'Toute division de la matière en corps indépendants aux contours absolument déterminés est une division artificielle . . . Tout mouvement en tant que passage d'un repos à un repos est absolument indivisible'.

9 Letter to Nino Brabantini, quoted in Ballo, op.cit., p.220. Ballo dates the letter September 1910, perpetrating an earlier error (see Marianne W. Martin, *Futurist Art and Theory*, 1909–15, Oxford, Clarendon Press, 1968, p.83 fn. 1). When the painting was first shown, at the Esposizione Libera of 1911, it was called *Lavoro*.

10 Letter to Brabantini of 9 May 1911, quoted in Ballo, op.cit., p.222.

11 The poem appeared under this title in *La Vie Charnelle* (8e. edition) Paris 1908.

12 Boccioni died on 17 August 1916, as a result of injuries sustained the previous day in a fall from a horse, while serving with the artillery stationed at Sorte, near Vicenza.

13 Letter to Brabantini of 11 May 1912, quoted in Ballo, op.cit., p.222.

14 Soffici's article *Arte Libera e Pittura Futurista* appeared in *La Voce*, no.25, 22 June 1911. The account of the Futurists' physical counter-attack has been frequently told (see M. Martin, op.cit., p.81).

15 In *La Voce*, II no.41, 22 September 1910.

16 In *La Voce*, III no.34, 24 August 1911, Soffici mentions an article by the French critic Roger Allard, entitled *Sur Quelques Peintres*, which had come out in *Les Marches du Sud-Quest*, no. 2., 7 June 1911. The Allard article reproduced, among other works, an 'Eiffel Tower' by Delaunay and Léger's 'Nus dans un Paysage'. The visual evidence would suggest that Soffici showed the illustrated article to Boccioni before the latter's trip to Paris. Boccioni later asserted that he had known Cubist works in reproduction before going to Paris (*Pittura Scultura Futuriste: dinamismo plastico*, Milan, Poesia, 1914, p.148).

17 Boccioni claimed that the preface was based on a lecture he gave to the Circulo Artistico in Rome in the late spring of 1911. The passages from the lecture quoted in *Pittura Scultura Futuriste*, however, do not mention 'lines of force' or 'battles of planes'.

18 The relevance of Cottet's tryptich is mentioned only by Alberto Martini, in his review of Ballo's *Boccioni*, which appeared in *Paragone*, XVI, July 1965, pp.61–7.

19 See M. Martin, op.cit., p.126.

20 Letter to Vico Baer reprinted in Joshua C. Taylor, *Futurism*, Museum of Modern Art, New York, 1961, p.134.

21 Severini, *Tutta La Vita di un Pittore*, Milan, Garzanti, 1946, p.185.

22 In *Pittura Scultura Futuriste*.

23 Illustrated in M. Martin, op.cit., facing p.72.

24 *Archivi* I, p.288.

25 J.F. Marey *La Machine Animale* (*Locomotion Terrestre et Aérienne*), Paris 1873.

26 M. Martin, op.cit., p.172.

27 A.E. Elsen, *Rodin*, New York, 1963, pp.173–4, 212.

28 Severini, op.cit., p.163. See also Ballo, op.cit., p.351. Apollinaire's review appeared in *L'Intransigeant*, 21 June 1913.

29 'I Futuriste Plagiati in Franca', *Lacerba*, 1 April 1913.

30 In an open letter to Papini, *Il Chercio Non Si Chiude*, *Lacerba*, 1 March 1914.

31 Boccioni does mention Kandinsky favourably, although he seems uncertain whether to include him in the German or the Russian category.

Biographical Outline

1882
Born 19 October at Reggio Calabria, Italy, son of a petty official of the prefecture. Spent early childhood at Forlì, Genoa and Padua.

1887
Family moved to Catania, Sicily. Completed education at the Istituto Tecnico.

*c.*1898
Went to Rome to paint. Met Severini and Balla, who introduced him to Divisionist techniques.

1902−07
Travelled in Italy, visited Paris and St Petersburg. Finally settled in Milan late 1907.

1906
Probably made first prints in Venice.

1907
Expressed a wish to paint modern industrial society.

1908
Began to paint industrial scenes. Painted 'Treno a Vapore', one of his first attempts to suggest movement. Met Carrà.

1909
Met Marinetti.

1910
Signed *The Manifesto of Futurist Painters* (11 February) and *The Technical Manifesto of Futurist Painting* (11 April). First one-man exhibition at Ca 'Pesaro, Venice.

1911
Exhibited work at the Esposizione d'Arte Libera exhibition in Milan. Futurist works attacked by Soffici in *La Voce*. Went to Rome to meet Soffici, whom he assaulted, though later became a loyal friend. Lectured on Futurism at Circolo Artistico Internazionale, Rome. Visited Paris with Carrà and Severini. Began to adopt some Cubist techniques in his work. Painted the 'States of Mind' triptych. Started to make sculpture late 1911 or early 1912.

1912
Exhibited in the first Futurist exhibition at Galerie Bernheim-Jeune, Paris (later at the Sackville Gallery, London, and in Berlin, Brussels, The Hague, Amsterdam and Munich). Met Apollinaire, Duchamp-Villon, Archipenko and Brancusi. Published *The Technical Manifesto of Futurist Sculpture* (11 April). Exhibited sculpture at Salon d'Automne, Paris. Began working on series of figures in action.

1913
Exhibited in the first exhibition of Futurist sculpture at Galerie La Boëtie, Paris, where he gave a talk on Futurism. Signed *The Futurist Political Programme* (11 October). Exhibited work in the Sprovieri Gallery, Rome.

1914
Wrote article in *Lacerba* in answer to Papini's article 'The circle closes'. Published *Pittura Scultura Futuriste: Dinamismo Plastico*. Exhibited at the Doré Gallery, London and Sprovieri Gallery, Rome. Signed *The Futurist Synthesis of the War Manifesto* (September). Arrested for taking part in a demonstration in Milan.

1915
Exhibited at the Panama-Pacific International Exposition at San Francisco, where his essay 'The exhibitors to the public' was published in the catalogue. Enlisted as a volunteer cyclist in the First World War and saw action. Returned to Milan on leave in December.

1916
Painted portrait of the musician, Ferruccio Busoni, in a style recalling Cézanne. Called back to fight in July and assigned to the artillery; stationed at Sorte, near Verona. Fell from a horse during military exercise and died from injuries 17 August.

Selected Bibliography

Boccioni's Writings

Pittura Scultura Futuriste: Dinamismo Plastico, Milan, 1914.

Monographs and General Studies

Apollonio, Umbro (ed), *Futurist Manifestos*, London, 1973.

Argan, Giulio Carlo, *Umberto Bocciono*, Rome, 1953.

Ballo, Guido, *Boccioni: La Vita e l'Opera*, Milan, 1964.

Calvesi, Maurizio and Coen, Ester, *Boccioni: L'Opera Completa*, Milan, 1983.

Carrieri, Raffaele, *Futurism*, Milan, 1963.

Gambillo, Maria Drudi and Fiori, Teresa (eds), *Archivi Del Futurismo*, 2 vols, Rome, 1958–62.

Golding, John, *Boccioni's 'Unique Forms of Continuity in Space'*, Newcastle upon Tyne, 1972.

Martin, Marianne W., *Futurist Art and Theory*, Oxford, 1968.

Tallarico, Luigi, *Boccioni, Cento Anni*, Rome, 1982.

Tisdall, Caroline and Bozzolla, Angelo, *Futurism*, London, 1977.

Exhibition Catalogues

Futurism, Museum of Modern Art, New York, 1961.

Futurismo 1909–1919, Newcastle upon Tyne and Edinburgh, 1972–3.

Boccioni a Milano, Palazzo Reale, Milan, 1982–3.

Boccioni, Prefuturista, Palazzo Venezia, Rome, 1983.